PICASSO BREAKING THE RULES OF ART

BY DAVID SPENCE

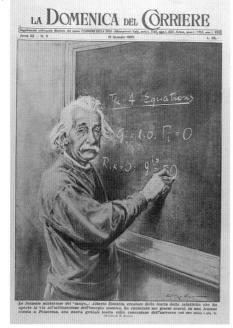

IT'S ALL RELATIVE

In 1905 the German-born scientist Albert Einstein published his first theory of relativity. His theories showed that time would slow down if you could travel at the speed of light, which was the fastest thing in the universe. His discoveries guided nuclear science and the eventual creation of the atomic bomb.

The Artist And His Times THE WORLD IN THE 1900S

he nineteenth century is said to have ended not in 1900 but in 1914 with the start of World War I. The period leading up to 1914 was the quiet before the storm that was to break with such force and devastate a whole generation. Rumblings could be heard in those quiet

years that were a prologue to an entirely new era that swept away the old ruling classes in Europe and changed established

ways of thinking forever. It was not just political and social change. Einstein's theories challenged the very principles upon which our knowledge of the world was based. The invention of powered flight, the cinema, wireless communications (radio), and much more was to have an effect far beyond the grasp of those living in the first decade of the twentieth century. In 1907 Pablo Picasso painted a picture that broke all the rules of

the last five hundred years of art. The painting, called *Les Demoiselles d'Avignon*, was to have an effect as powerful as any of the inventions of his day.

A CAR FOR EVERYONE

In 1908 Henry Ford opened a factory to produce cars. He used a new method called the "production line" which enabled cars to be manufactured at prices cheap enough for ordinary people to afford.

Assessing the second states and the

THE ART CAPITAL

CL Extension Cleaned (Clint) - - Extension Content (Record) -

By 1900 Paris had a reputation as the art capital of the world. Artists of all nations traveled to the city to follow in the traditions of the now famous Impressionists such as Claude Monet. They crowded into the Bohemian Ouarter of Montmartre and could be seen in animated discussion in the many cafés that offered cheap food and entertainment.

THE MOVIES

The first motion pictures had been presented by the Lumiere brothers to a disbelieving audience in Paris in 1895. In 1905 a film theater opened in the United States. It charged one nickel admission, and was therefore called the Nickelodeon. In 1907 the motion picture industry found its natural home in the balmy climate of Southern California and has stayed there ever since.

POWERED FLIGHT

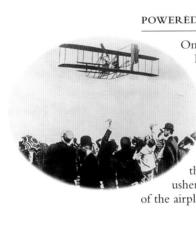

On December 17, 1903, at Kitty Hawk, North Carolina, two brothers made the first ever powered flight. The first flight lasted just 12 seconds but subsequent flights lasted up to 59 seconds. Orville and Wilbur Wright, flying in the aircraft they named Flyer, ushered in the age

of the airplane.

BRITISH IMPERIAL POWER

Victoria, queen of Great Britain and Ireland, and empress of India, died in the sixty-fourth year of her reign in January 1901. Victoria had ruled over an empire that touched every corner of the globe and which, without doubt, exerted the greatest power and influence in the world. The supremacy of the British naval fleet helped maintain the huge empire that gave Britain enormous wealth. Spurred by commercial competition, rival nations such as Germany began to challenge the dominance of the British Empire.

3

THE PARTY OF THE

THE ARTIST AND HIS TIMES THE WORLD OF PICASSO

icasso was born in the Andalusian city of Málaga on the southern coast of Spain on October 25, 1881. Legend has it that at birth he had to be brought to life by an uncle who blew cigar smoke into his nose. When baptized his full name was made up from no fewer than fourteen names, the first Pablo, the last two Ruiz Picasso. He eventually came to use his mother's surname. Picasso, in favor to that of his father, José Ruiz Blasco. His father was a drawing teacher at a local art school who supplemented his poorly paid job with another as curator at the local museum and yet a third as a picture restorer. When Picasso was ten years old the local museum closed, and Don José took a teaching post at the School of Fine Arts in the Atlantic port of La Coruña. The family moved with him. It was shortly afterwards that Don José, recognizing his son's talent for art, decided to give up painting himself and concentrate on developing young Pablo Picasso's career as an artist.

THE YOUNG PICASSO

Picasso arrived in Paris in October 1900 with his companion Carlos Casagemas. They took up residence in the Montmartre studio of a Spanish artist, Isidre Nonell, who had decided to return to Spain. Picasso stayed long enough to find an art dealer who offered to sell his work before returning to spend Christmas with his family in Spain. He went back to Paris in May the following year, but his friend Casagemas was dead, having committed suicide after an unhappy love affair.

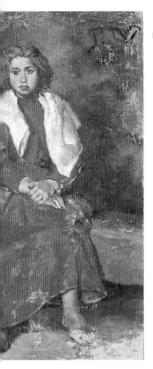

SCIENCE AND CHARITY, 1895

Picasso painted this academy piece when he was only fifteen years old. It received an honorable mention at the National Beaux-Arts exhibition of 1897 and a gold medal in a local competition in Picasso's home town of Málaga. The doctor who is taking the pulse of the sick woman is based on his father, identifiable from the reddish

GIRL WITH BARE FEET, 1895

Picasso was born an artist. It is said that he could draw before he could talk, and when he could talk his first word was "pencil." Don José started teaching his son painting from the age of seven. When he was thirteen Picasso finished a sketch his father had started, and when Don José saw what Picasso had done he handed him his palette and brushes, vowing never to paint again. The thirteenyear-old Picasso enrolled at the Academy of Fine Arts where his father taught. When he was fourteen he painted *Girl with Bare Feet*. The model is unknown but is clearly of a girl of about the young Picasso's age. It is a stunning painting for one so young. The picture remained one of Picasso's favorites for many years and may have reminded him of his little sister, Concepcion, who died the same year.

arrefermenter se Alaman verstallet i Statistiken verstellter verstalltaten verställter som av Alam

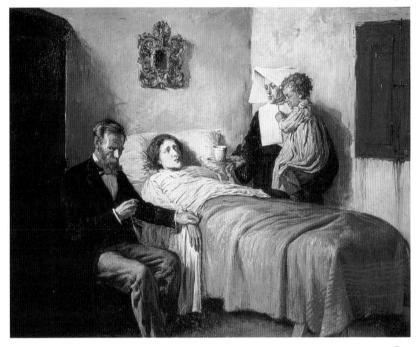

blonde hair. The picture demonstrates Picasso's early artistic skill. Although seeming rather stilted in contrast to *Girl with Bare Feet*, it is full of poignancy. Has Picasso reversed the roles of the sick mother and the little daughter who looks on from the nurse's arms? Concepcion's death could not have been far from his thoughts.

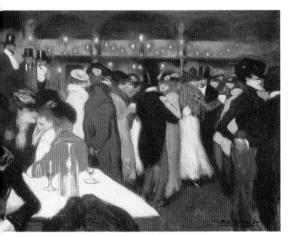

LA MOULIN DE LA GALETTE, 1900

Picasso briefly attended the Academy at Madrid, then Barcelona, but his teachers appeared to have nothing to offer him. The city of Barcelona, however, gave Picasso access to new artist friends who copied the Bohemian café life of Paris. Picasso gained a sense of freedom but still wanted to see for himself the new art of London and Paris. In 1900 he set out for London, stopping in Paris on the way. It is no coincidence that his first picture of Paris was of the Moulin de la Galette, a favorite haunt of the Impressionists whom Picasso must have heard so much about.

n seessa and a the seessa with a second state of the second second second second second second second second se

MUSIC, 1910 Henri Matisse

Matisse, older than Picasso by twelve years, was working in Paris at the same time as Picasso in the early 1900s. Matisse's obsession was the exploration of color to express emotion. He was the "king" of the Fauvist painters and was the undisputed leader of the new art after his exhibition at the Salon in 1906. Picasso, however, was to become more influential, particularly as cubism, with Picasso's involvement, became the accepted way forward towards the modern art of the twentieth century.

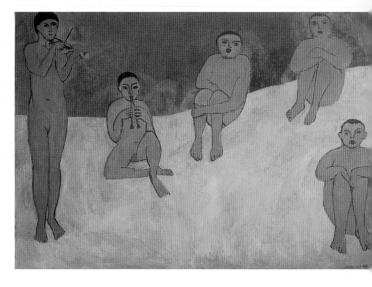

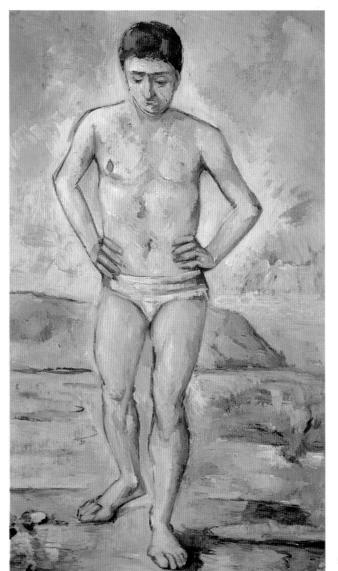

THE GREAT BATHERS, 1885/87

Paul Cezanne

Cezanne was born in the South of France in 1839, only taking up painting when he came to Paris in the 1860s. Although working and exhibiting alongside the Impressionists, he was dissatisfied with their approach and said that he wanted to "make of Impressionism something solid and durable, like the art of the Museums." Cezanne's influence on twentieth-century art has been profound, many attributing the basic ideas of cubism—seeking to represent the structure and form of objects, not just their surface—to him.

MOULIN ROUGE

Henri Toulouse-Lautrec

Although Toulouse-Lautrec died shortly after Picasso first came to Paris, his work impressed and influenced Picasso. Toulouse-Lautrec's studies of the dance halls and bordellos with their dispassionate gaze onto the seedier side of

Parisian life encouraged Picasso to seek similar subjects. Although hints of Toulouse-Lautrec's painterly style can be seen in Picasso's very early paintings from this period, attention to the same subject matter is more noticeable. Picasso's early blue period paintings, so-called because of the predominantly blue hues, include studies of the sick prostitutes who visited the Saint-Lazare Hospital.

THE ARTIST AND HIS TIMES THE ART OF HIS DAY

icasso's life and career spanned nearly a century. When he first visited Paris in 1900, he entered a city that was alive with artists pursuing new and different approaches to painting. Impressionism was well known; its leading exponent, Claude Monet, had gained international recognition. Breakaway groups such as the Pointillists were challenging impressionism; Edgar Degas and Pierre-Auguste Renoir were following individual paths; loners such as Paul Gauguin and Vincent van Gogh had developed highly individual styles. At first Picasso experimented with these new influences but quickly established his own way of painting that soon had its followers,

known as "La Bande Picasso." By 1905 a new style of painting had developed called fauvism, led by Henri Matisse. The principle aim of Fauvism was to use color as a means of expression. Matisse and fellow artist Paul Cezanne greatly

influenced the course of painting at the beginning of the century, but none has contributed as much as Picasso, who always remained an individual while working alongside artistic movements such as cubism, surrealism, expressionism, futurism, and many more "isms."

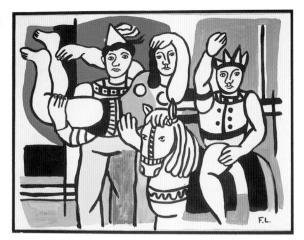

LES ACROBATS, 1930

Fernand Leger

Leger was one of the painters fully committed to cubism, along with Georges Braque and Juan Gris, but developed his own particular style that was based on cylindrical and conical forms. Although Picasso painted in a similar way to the Cubist painters from as early as 1909, he was always exploring new methods and styles. When Picasso saw the Cubist paintings in Paris at the Salon des Independants in 1911 he was described by his friend Guillaume Apollinaire, as "sympathetic but trying not to laugh." This is a good example of how Picasso would take what he needed from a new movement in art and then move on, rather than become fixed with one idea and style, as did many of the Cubists.

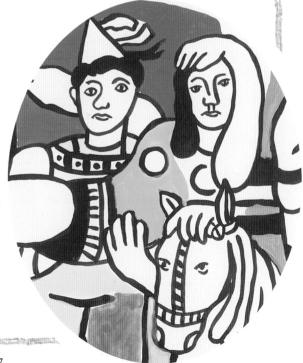

THE ARTIST'S LIFE FAMILY AND FRIENDS

PICASSO AND FERNANDE OLIVIER

This photograph, taken in the Café El Guayaba in Barcelona in 1906, shows Picasso with his lover, Fernande. Fernande had moved into the Bateau Lavoir

with sculptor Debienne. Another affair with painter Sunyer followed before she moved in with Picasso in 1904. Fernande published her memoirs in 1988, in which she writes about the beginning of her affair with

Picasso. "One Sunday, under a burning sun, I took my things over to Picasso's. A whim had thrown me into your arms one stormy day. Then, suddenly, I withdrew and you suffered from that for months. Then I called

you. You were working, but you dropped your canvas and brushes and came running." It may be that the change from Picasso's melancholy

"blue period" paintings after the death of friend Casagemas to the warmer "rose period" from 1904 was as a result of his encounter with Fernande.

icasso resembled his mother. Maria Picasso Lopez, a petite Andalusian with eyes as black as her hair, rather than his father who was tall with reddish hair that led to his nickname "the Englishman." Picasso was encouraged to draw and paint at an early age by his father, whose own paintings Picasso later described as "dining room pictures, the kind with partridges and pigeons, hares and rabbits, fur and feather." He had two younger sisters, Lola and Concepcion. Concepcion, or Conchita as she was affectionately known, died of diphtheria when she was just eight years old. We can only speculate on the effect her death had on the fourteen-yearold Picasso, but in later life he could not bear to be near people who were ill. After Picasso moved to Paris, he made many friends, including the poet Guillaume Apollinaire and the strange writer Alfred Jarry whose play, Ubu Roi, caused a riot when it opened in a Paris theater. Picasso's first love was Fernande Olivier whom he met when he moved in 1904 to the Bateau Lavoir (Laundry Barge), the name given to the apartment block in Montmartre now famous for its association with so many artists.

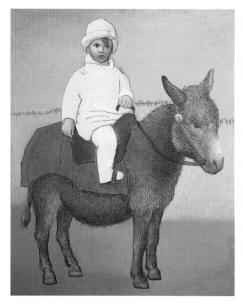

PAULO ON A DONKEY

On February 4, 1921, Olga gave birth to a son who was named Paulo. Picasso became, for a while, a doting father and always delighted in making sketches and paintings of their son, such as the one shown here. By this time Picasso's work was very much in demand and sold for good prices. The family lacked for little in terms of material comforts, but the stability of family life did not last. Dissatisfaction, perhaps by Olga as well as Picasso, appeared after a few short years.

MA JOLIE, 1914

It was impossible for Picasso to be faithful to one woman. After Fernande's walked out on Picasso one summer evening in 1911, he started courting a friend of Fernande named Marcelle Humbert. Picasso called her Eva to signify first love, and it appears that Picasso really did fall deeply in love with her. They moved to a studio in Monparnasse where they became devoted to each other. Picasso told his art dealer that he loved Eva very much and would write it on his pictures. At this time the words Ma Jolie appeared on the painting. This was the name of a popular song, and it appears that Picasso adopted it as an affectionate name (my pretty one) for Eva. This love was not to last. Tragically Eva died from illness in 1915.

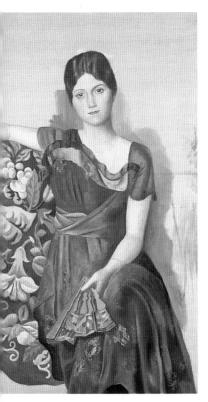

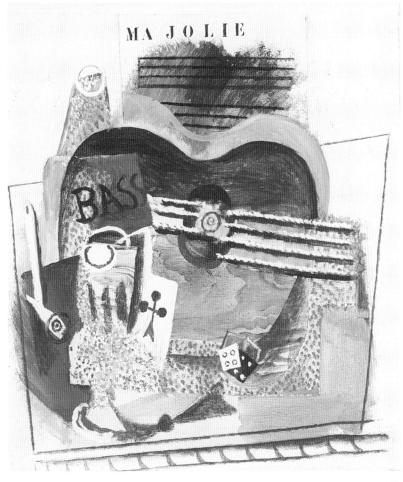

PORTRAIT OF OLGA IN AN ARMCHAIR, 1917

In 1915 Picasso met pianist and composer Erik Satie. At the time Satie was composing music for a ballet called Parade for the famous impresario Sergei Diaghilev. The scenario was being written by a young man called Jean Cocteau who was to become firm friends with Picasso. Picasso agreed to paint the backdrops. The ballet was a disaster when it opened in Paris in 1917 despite being performed by the world famous Russian Ballet. One of the dancers, Olga Khokhlova, daughter of a Russian general, caught Picasso's eye. In July 1918 Olga and Picasso were married.

The Life of Picasso

~1881~ October 25 Picasso is born in Málaga, Spain.

~1895~ Concepcion, Picasso's sister, dies at age eight.

~1897~ Wins a gold medal in a local art competition.

> ~1900~ Moves to Paris.

~1901~ Picasso's friend, Casagemas, commits suicide. His blue period starts.

n a on. emas, cts.

The Life of Picasso

backer with server that back the Thildren

~1904~

Meets Fernande Olivier at the Bateau Lavoir. His rose period starts.

~1905~

Leo and Gertrude Stein become important patrons.

~1907~ Paints Les Demoiselles d'Avignon.

~1909~

Beginning of cubism with George Braques.

~1911~ Falls in love with Eva (Marcelle Humbert).

~1912~ He makes first ever fabricated sculpture.

~1914~ Start of World War I.

~1915~ Eva dies after a long illness.

~1918~ Marries Olga Khokhlova.

> ~1921~ Birth of son Paulo.

~1927~ Meets Marie-Thérèse Walter.

~1933~ Spanish Republic declared.

> ~1934~ Hitler's Night of the Long Knives.

~1935~ Separates from Olga. Birth of daughter Maya.

MAYA WITH Sailor Doll, 1938

Maya inherited the blond hair and blue eves of her mother. Picasso and Olga had separated, but divorce was not possible, so Picasso could not marry Maya's mother. Picasso tried to sustain his life as a painter while Olga and son Paulo, and Marie -Thérèse Walter and daughter Maya, lived in different parts of Paris. Meanwhile disturbing news about activities in Nazi Germany started to come to light, and in 1936

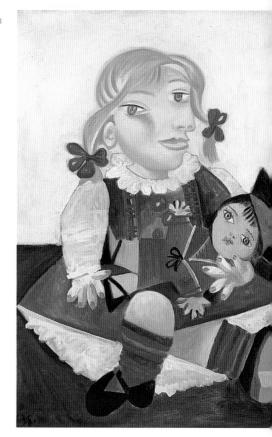

Picasso's beloved Spain fell into civil war, the destruction aided with help from Nazi Germany. This portrait of Picasso's three-year-old daughter seems almost sinister. It is as if Picasso's work, by now filled with the horrors of war, cannot permit him to regain the innocence of the infant.

FRANÇOISE GILOT WITH PALOMA AND CLAUDE, 1954

Picasso had actually lived alone since the break-up with Olga, spending only weekends and holidays with Marie-Thérèse and short periods of time with Dora Maar. With Françoise Gilot, whom he met in 1943, he felt differently. Picasso first met Françoise when he was living in Nazi occupied Paris. By the time the war had ended in 1945, the sixty-four-year-old Picasso and Françoise, some forty years younger, were lovers. They

lived together in Antibes where in 1947 Françoise had a son, Claude. Shortly afterwards they had another child, a girl they called Paloma.

The Artist's Life NEW LOVES

v his mid-forties Picasso was truly a success. The impoverished days as a Bohemian in the poor quarter of Paris had given way to the wealth and comfort of his villa on the Mediterranean coast, limousines with chauffeursand an unhappy marriage. In 1927 Picasso met a seventeen-year-old girl on the streets of Paris. Her name was Marie-Thérèse Walter and they began a love affair soon afterwards. Picasso was still married to Olga, so the meetings between Marie-Thérèse and Picasso were secret. His paintings at this time would have given the game away had Olga looked carefully, although it would seem this was something she had no interest in doing. Marie-Thérèse eventually had a child by Picasso whom they named Marie-Concepcion, Maya for short. Picasso's first daughter bore the name of the sister who had died forty years earlier in Spain.

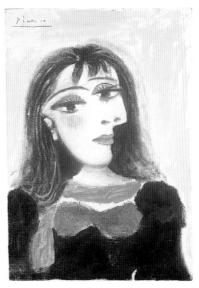

DORA MAAR, 1937

In 1936 Picasso's friend Paul Eluard introduced him to the photographer Dora Maar. She was "inclined to storms—with thunder and lightning," according to a close friend. Picasso immediately fell for her, and they became lovers. Picasso made this portrait of her at the same time that he was painting Marie-Thérèse, and it appears that there was no conflict between the two women. For his part Picasso showed no sign of losing interest in Marie-Thérèse.

PORTRAIT OF MARIE-THÉRÈSE WALTER, 1939

Marie-Thérèse, remembering her first meeting with Picasso, recalled that "I was seventeen years old. I was an innocent young girl. I knew nothing - either of life or of Picasso. Nothing. I had gone to do some shopping at the Galeries Lafayette and Picasso saw me leaving the Metro. He simply took me by the arm and said: 'I am Picasso. You and I are going to do great things together'."The relationship remained secret for years. It is not known at what point Olga found out about Marie-Thérèse but probably in 1935 when Marie-Thérèse was pregnant with Maya. Legend has it that when a man called at Picasso and Olga's apartment to value the property as a basis for the separation settlement Olga fainted.

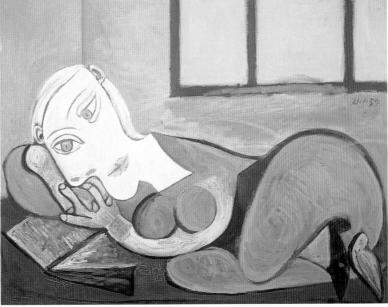

THE ARTIST'S LIFE LATER YEARS

icasso's life with Françoise and

PICASSO IN HIS STUDIO WITH MODEL SYLVETTE DAVID

Picasso did not slow down towards the end of his life. He was still painting hundreds of canvases and making hundreds of prints every year. The writer, Helene Parmelin, in her notes about Picasso's output, demonstrates his obsession with paint and canvas "On 2 March Picasso did 4 paintings; the painter and his model, and a green nude. On the 4th,

a white nude plus 2 canvases with the painter's head. And on the 10th, a canvas of the painter alone in front of his painting. On the 13th, the nude holds a glass at arm's length, while

the painter goes on working. On the 14th, the nude has left the scene, is sleeping perhaps. In any case the solitary painter is working at his easel in the studio. On the 25th the painter is still alone." This obsession grew stronger as Picasso grew weaker. He

painted right up to his death on April 8, 1973. Just months before his death and in his ninety-second year he said of a drawing: "I did a drawing yesterday;

and I think maybe I touched on something. It's not like anything I've done before.'

J the children lasted until 1953. / Françoise decided she could no longer put up with his continual need to see both Marie-Thérèse and Dora Maar, apart from other occasional love affairs. She took the children with her to Paris. Francoise's memoirs recall Picasso with a certain bitterness that is perhaps understandable: "Picasso had insisted that I have children because I was not enough of a woman. And so I had them. One might have thought that I was, therefore, more of a woman, but it became clear that the whole question was for him a matter of complete indifference." Picasso was alone once more, but he could never be alone for long. After the departure of Françoise with

Claude and Paloma, he met Jacqueline Roque.

PICASSO WITH JACQUELINE ROQUE

Jacqueline Roque became Picasso's second wife. It would seem they met in the town of Vallauris in the South of France where Picasso lived and worked in 1953. Olga's death in 1955 meant Picasso was free to marry, and after some years with Jacqueline, they were finally married in 1961. This photograph taken in 1957 shows them together in la Californie, the house they

shared in Cannes. The huge house with its high-ceilinged rooms and views over Cannes Bay became one enormous studio where Picasso

continued his immense production of paintings and sculptures.

Jacqueline had a daughter, Cathy, from a previous relationship. This photograph shows Picasso and Jacqueline with Cathy and Picasso's two children from his relationship with Francoise, Claude and Paloma.

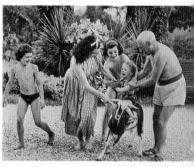

THE LIFE OF PICASSO

~1936~ He meets Dora Maar.

~1937~

On April 26 Germans bomb Spanish town of Guernica. He paints Guernica mural for Spanish Republican pavilion.

~1939~ Beginning of World War II.

~1943~ He meets Françoise Gilot

> ~1945~ End of World War II.

~1947~ Birth of son Claude.

~1949~ Birth of daughter Paloma.

~1953~ Françoise moves out with Claude and Paloma.

~1961~ He marries Jacqueline Roque.

~1967~ A Picasso painting sells for the highest ever price for work by a living artist.

~1973~ Picasso dies on April 8.

~1981~ Sale of self-portrait for \$5.5 million breaks all records.

PORTRAIT OF JACQUELINE ROQUE WITH CROSSED ARMS, 1954

Jacqueline became the subject of his paintings, just as all his women had been throughout his life as an artist. He painted her obsessively, reducing the form to shapes and colors, lines and textures. Life at la Californie was full and varied as Picasso's political interests (he had long been a member of the French Communist Party) sparked debate when Soviet tanks rolled into Hungary. Film stars such as Yves Montand and Gary Cooper visited as did old friends such as Jean Cocteau.

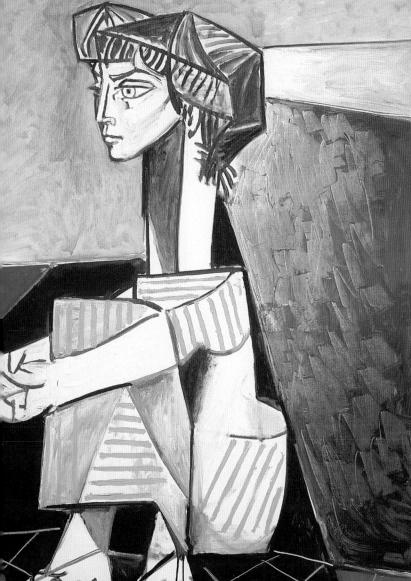

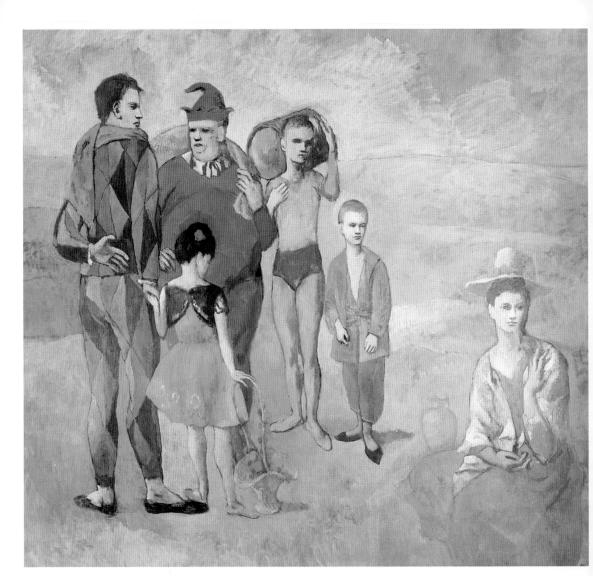

FAMILY OF SALTIMBANQUES, 1905

The Saltimbanques is almost a roll call of all the circus characters in one painting. It was the largest canvas Picasso had attempted to date, over two meters (six feet) square, and recaptures the full range of colors lost in his blue period. There is an overwhelming seriousness about the characters in Saltimbanques, quite at odds with the public perception of their roles as entertainers. As with his other pictures of this time, we do not know the significance of the group, but it is interesting to note that a little girl with a basket of flowers is holding the harlequin's— Picasso's—hand. She would be about the same age as Picasso's lost sister, Concepcion.

APOLLINAIRE AND FERNANDE

Some have suggested that the fat jester (right) represents his friend, Apollinaire, and the seated woman (left) Picasso's lover, Fernande Olivier.

THE ARTIST'S VISION WHAT DO THE PAINTINGS SAY?...

The figure wearing the harlequin's costume is Picasso himself. rom 1901 to 1904 Picasso's paintings became predominantly blue, and, as a consequence, this period has become known as his blue period. The reasons why his work became dominated by one color are speculative, but certainly the loss of his friend, Carlos Casagemas, had a profound effect upon Picasso

that in turn affected his painting. Casagemas was a fellow artist who had traveled to Paris with Picasso in 1900. They had lodged together in Montmartre, but when Picasso returned to Spain at Christmas, Casagemas stayed with his newfound lover, Germaine. The affair was short-lived and tragic, ending with Casagemas shooting himself in the head in the back room of a Parisian wine shop in February of the following mean "It was thinking

following year. "It was thinking about Casagemas that got me started painting in blue," Picasso admitted in later life.

YOUNG GIRL ON A BALL, 1905

Picasso had spent much of the time since Casagemas's death in Barcelona, but in April 1904 he returned to Paris where he was to stay. He moved into the Bateau Lavoir where he met Fernande Olivier who described Picasso as, "small, black, thick-set, restless, disquieting, with eyes dark, profound, piercing, strange, almost staring... a thick lock of hair, black and shining, slashed across his intelligent and obstinate forehead." His spirits lifted and his paintings became full of harlequins and circus people. The blues changed to pinks. The time from 1904 to 1905 has

become known as the rose period or circus period. Picasso and his friends met once a week at the Circus Medrano where they went behind the scenes. Picasso made friends with the harlequins, jugglers, and strolling players. His paintings of the subject, however, are composed in an almost classical manner.

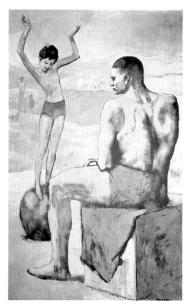

The seated figure in Young Girl on a Ball is painted in a style that is more like Michelangelo than his contemporary artists.

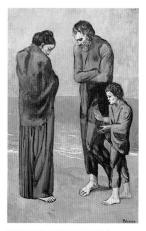

THE TRAGEDY, 1903

Picasso was deeply upset by the death of his friend. In addition to his sadness, he was poverty-stricken and was having little success with his painting. He spent much of his time in Spain, locked away and devoting his time to painting. When he did make periodic visits to Paris, he no longer found a market for the paintings that he had when first in the city. He was trying to make a

memorial to his friend but was continually dissatisfied with his efforts. There is no doubt that The Tragedy speaks of the terrible loss of Casagemas, even though we do not know who the characters are and why they stand huddled on the beach. Picasso later said "I certainly didn't intend to paint symbols; I simply painted images that rose in front of my eyes; it's for others to find a hidden meaning in them." The style and overall blue hue, are however, typical of the paintings he made during this period.

THE ARTIST'S VISION ...WHAT DO THE PAINTINGS SAY?...

y 1906 Picasso was beginning to get noticed in the right circles. The Parisian art critics were now paying attention to the twenty-five-year-old artist whose

exciting works were rivaling Matisse. In the summer of that year, Picasso and Fernande left Paris for the tiny village of Gosol in the Pyrenees. So inaccessible was it that their luggage had to be carried on muleback. The pictures he painted in Gosol indicated that he was not continuing with the attractive compositions of the rose period but experimenting with a new style. A typhoid epidemic caused Picasso and Fernande to leave Gosol later that summer. Picasso carried back to Paris his paintings, sketches, and ideas that had formed in the remote

AFRICAN MASK

Art from different cultures began to influence Picasso and his fellow artists. Matisse had bought an African mask and André Derain had visited the British Museum collection of African art. Iberian Primitive art was on show at the Louvre at the time, some of which, apparently, had been stolen and turned up in the artist's colony

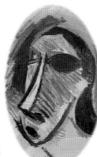

where Picasso worked. The violently misshapen and striped faces of the figures on the right in *Les Demoiselles d'Avignon* owe much to these new influences. mountain village. During the spring and summer of 1907, Picasso worked on a painting

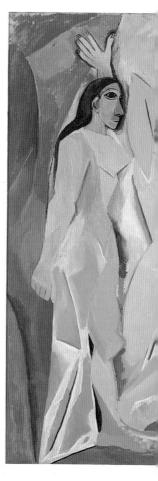

that was to break with the artistic traditions that had dominated western art for the previous five hundred years. This painting was initially called *le Bordel* (The Bordello) but became known as *Les Demoiselles d'Avignon* (The Young Ladies of Avignon).

SELF-PORTRAIT IN 1906

A few of Picasso's friends and acquaintances saw *Les Demoiselles d'Avignon*. None could understand it, not even his close friends. Picasso felt isolated, and, to make matters worse, he had separated from Fernande. The young art dealer, Daniel Kahnweiler, seemed to have recognized the painting's worth but said, "The picture... struck everyone as something mad and monstrous."

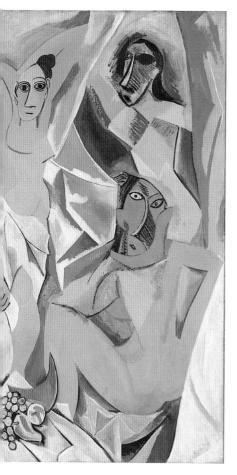

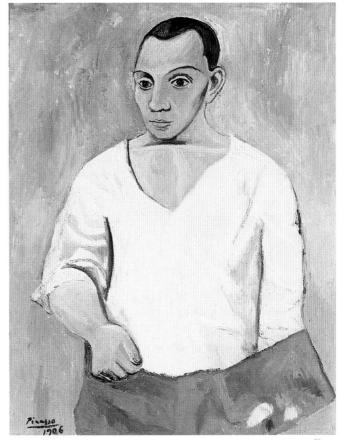

BREAKING THE RULES OF ART LES DEMOISELLES D'AVIGNON, 1907

The great developments in art during the Renaissance in the fifteenth century led artists to represent their subject in a realistic way. Studies of human anatomy and the employment of perspective helped artists to paint pictures that "tricked" the viewers into thinking that what they saw was a real extension of the world, not a flat surface. This was, of course, an illusion. These artistic conventions continued into the twentieth century. One painting more than any other served to bring about a change in this tradition, and that was *Les Demoiselles d'Avignon*. It was the prologue to the movement called cubism which was to break the Renaissance tradition and prepare the way for the art of the twentieth century.

Picasso made countless sketches for the painting that was to be the biggest yet, over two meters (six feet) square.

The painting started out with a sailor and a student with naked women in a brothel. As Picasso worked away at the picture, it gradually changed over a period of months during the summer of 1907. The student and sailor made way for more women and, importantly, the influence of "Primitive" art makes a dramatic impact. The figures jump violently from the background. The angularity and unharmonious composition makes the eye travel unhappily across the picture, leaping from one distorted face to another. The radical departure from traditional painting is evident; no longer can the viewer try to understand the picture as an extension of the real world, there is no perspective to give the painting depth, there is no attempt at illusion. Picasso has made a new type of painting.

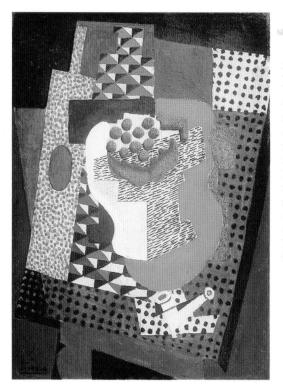

VIOLIN, 1911/12

The Cubist style of painting attempted to display frontally, parts of a depicted object that might be observed from any angle. Painting in this way would display all facets of an object flattened out to be seen from the front. Braque's manner of painting literally squared everything-houses, trees, landscapes-into cubes. Picasso's paintings sought to explode the object, to take it apart visually in order to see what it was made of. to "deconstruct" what he saw. This painting of a violin, which was made in 1911, demonstrates the technique. Many views of the same object are displayed on the flat plane of the picture surface.

Picasso has chosen to emphasize certain parts of the violin more than others. The clef-shaped cutout from the front of the violin sound box is prominent, as is the wood grain. The bridge and strings move diagonally from left and upward from bottom center. Not only has the violin been flattened, but Picasso has chosen what he considers to be the most important visual elements of the object and accentuated them while allowing others, including the true shape of the violin, to be lost.

BOTTLE AND PIPE

With this painting, made in 1915, Picasso was very close to completely abstract art. Braque had stated that, "when the fragmentation of objects appeared in my paintings around 1910, it was a technique for getting closer to the object." The normal everyday objects found in the cafés of Paris, such as newspapers, were now not only the subject of Picasso's paintings but were sometimes physically part of the painting (collage). Picasso was recreating the world around him, but not in a way that imitated reality.

THE ARTIST'S VISION ...WHAT DO THE PAINTINGS SAY?

fter painting Les Demoiselles d'Avignon, Picasso turned the canvas to face the wall. It had not been well received and was not to get a full public airing until several years later when it was received with indifference. Picasso was well aware of the importance of his painting, as was another artist, Georges Braque, who had not

> openly praised the picture but had been impressed. Braque was a great follower of Cezanne who had taken landscape painting one step further by beginning to turn everything into geometric shapes. Six paintings submitted to the Salon by Braque in the autumn of 1907 were reviewed by Matisse, who was on the selection jury. Matisse commented that Braque had reduced everything to petit cubes (little cubes). The critic Louis Vauxcelles described them as "Cubist," and the name stuck. Braque and Picasso watched each other's work carefully. Following on from Les Demoiselles d'Avignon Picasso's work developed a distinctly Cubist style.

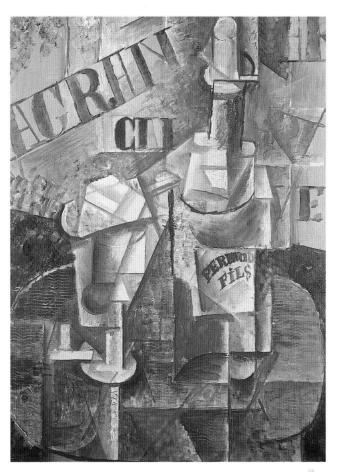

BOTTLE OF PERNOD, 1915

From 1907 Picasso, Braque, and others, particularly Leger and Gris, continued to explore the new Cubist view of the world. Picasso appears now to have been liberated from the tyranny of having to represent what he saw in the traditional way and was moving quickly towards nonrepresentational or abstract art. It is still possible to make out what is depicted in Bottle of Pernod. A bottle and glass stand on a table. Advertising signs full of words fill the background. Picasso shows as much, perhaps more, interest in the flat words as he does in the threedimensional objects and paints them with equal emphasis.

Picasso made another invention in 1912 that was to have an enormous impact. When making a painting of a still life of a café scene, he decided to glue a piece of oilcloth with a chair caning overprint onto the canvas. Braque followed Picasso's lead and also started to employ the technique called "collage." The paintings that followed incorporated more "real" objects such as newspapers, rope, anything that could successfully be stuck onto the canvas. In their pursuit of reality, the artists were making the paintings real with real things instead of representing them through the medium of paint.

The Artist's Vision HOW WERE THEY MADE?

with cubism came a new 4 approach to art. Both Picasso and Braque were pushing to the limits the way in which objects could be represented in a picture. This new art was no longer readily understandable by a wider public. They could not share the "illusion" of reality that previous artists had created on the flat picture plane because it had now been destroyed and replaced by the artist's personal view of that reality. The "personal" view of Picasso and Braque no longer relied on existing artistic conventions of representation. The two artists spurred each other onward and upward. As Braque was later to say "we were like two climbers roped together on a mountain." In 1912 they started making cardboard models of objects to assist with the paintings. Picasso suddenly realized that he was making Cubist sculpture, a totally new approach to the art form. Instead of carving from stone or modeling from clay he was constructing from sheet metal.

Picasso's interest in sculpture continued throughout his life. He was particularly fascinated by *objets trouves* (found objects). He would delight in taking everyday objects that he found lying around and, with the minimum of intervention, turn them into something else. An example of this was the *Bull's Head* which he made by fixing the handlebars of a bicycle to the top of a bicycle seat. When he was praised for seeing a remarkable likeness in such mundane objects he said, "That's not enough. It should

be possible to take a bit of wood and find that it's a bird." Picasso was happy creating things. When he was not painting, he was making sculptures using ordinary materials lying around the house or the studio.

THE GOAT, 1950

The realization that ordinary materials such as cardboard,

sheet metal, and wire could be turned into art was an enormous step in the progress of twentieth century art. Until that time it had not entered into anyone's head to make a sculpture from everyday objects and found materials. Picasso's *Goat* demonstrates what is possible; a palm forms the spine; a wicker basket, the swollen belly; ceramic jars, the udders; a metal lid folded in two, the genitals. After casting in plaster the final piece is realized in bronze, the

traditional sculptor's material.

Picasso made clay figures and ceramic pots that he painted in bright colors.

THE ARTIST'S VISION FAMOUS IMAGES

n 1936 Picasso's beloved Spain was plunged into civil war. The Republic of Spain, ruled by a weak popular government, faced an uprising from the right wing military generals, led by General Francisco Franco. Spain became a battleground for the international

forces of communism and fascism. In January 1937 the Spanish ambassador in Paris asked Picasso to contribute a mural painting for the Spanish pavilion of the Paris World's Fair. Picasso was not enthusiastic about the request and gave a non-committal reply. Guernica changed everything.

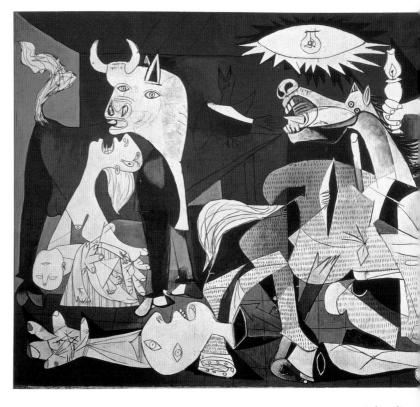

FRANCISCO FRANCO

After his victory General Franco ruled Spain through World War II and for thirty years thereafter. Although Picasso was keen that *Guernica* would one day find a home in Spain, his condition was that "the painting shall be turned over to the government of the Spanish Republic the day the Republic is restored in Spain." As years passed this clearly would not happen. It was later changed to "when public liberties are re-established in Spain." After Franco's death in 1975, new calls for the painting's return were made. Picasso's heirs (Picasso had died in 1973) and the Museum of Modern Art in New York finally agreed, and *Guernica* was installed in the Prado in Madrid. A howling mother carries

her dead child in her arms.

A dead soldier still clutching his broken

sword lies across the base of the picture.

NAZI LUFTWAFFE

On April 26, 1937, Republican troops gathered in the Basque town of Guernica in northern Spain. Franco enlisted the help of the German Nazi Luftwaffe (air force) who were keen to try out their new planes and had three squadrons stationed nearby. The squadrons were manned by German pilots who wore Spanish uniforms and were known as the Condor Legion. The bombing of the virtually undefended Guernica by the Nazi planes completely destroyed the town, and hardly a building was left standing. After the bombing the Nazis machine gunned civilians as they attempted to flee. As news of the massacre spread, the world was stunned into silence.

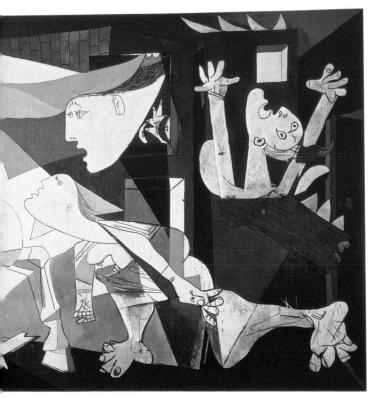

Picasso referred to the bull as brutality, darkness and dying; the horse as the people.

Here is a figure who appears to be consumed by the flames of a burning building.

A fleeing women runs beneath another who looks on in horror, arm outstretched clutching a lamp.

AN OCEAN OF Misery and death

When on April 27 news of Guernica reached Picasso through the world press only twentyseven days remained until the opening of the World's Fair. On April 30 the first photographs of the atrocity appeared. On May 1 Picasso started his sketches for the mural for the Spanish pavilion at the fair. He no longer doubted what he should do. While working on the mural he said "The war in Spain is a war of reaction-against the people, against liberty. My whole life as an artist has been a continual struggle against reaction, and the death of art. In the picture I'm now painting-which I shall call Guernica-and in all my recent work, I am expressing my horror of the military caste which is now plunging Spain into an ocean of misery and death."

GUERNICA, 1937

On May 11 Picasso started sketching out the composition for the painting on a canvas three and a half meters by over seven and a half meters long (twelve feet by twenty-five feet). The painting, which was made entirely in black

and white and shades of gray, could not be finished and exhibited in the Spanish pavilion until June. Picasso had created one of the most enduring images of the twentieth century and possibly his best-known work. It was, however, predictably, criticized by the fascists who called it "degenerate"—but also by the communists who called the painting "anti-social and entirely foreign to a healthy proletarian outlook."

PHOTOGRAPH OF PICASSO BY MAN RAY

In July 1938 Picasso moved to the south coast of France for the summer. He stayed in an apartment lent to him by artist Man Ray and was planning to stay throughout the summer, painting as usual. Picasso's stay was cut short by news of the death of a friend that took him back to Paris. As the prospect of war appeared to grow stronger, he hurried to join Marie-Thérèse and Maya in the Atlantic coastal town of Royan. He stayed there while the German forces marched into Paris on June 14, 1940, and when Royan itself was occupied by the German army shortly thereafter. Picasso then decided to return to occupied Paris where he was to stay until the end of the war, despite being invited by the Americans to move to the United States. Fellow artist Matisse had already made the same decision, writing "If everyone did his job as

Picasso and I are doing ours, all of this wouldn't be happening."

WEEPING WOMAN, 1937

To the occupying German forces, Picasso's work was a prime example of "degenerate" art. This was art that did not conform to the standards of Nazi culture, which only accepted traditional representative art. Paintings such as the *Weeping Woman*, which was based on Dora Maar but was a painting about grief and sorrow at the terrible occurrences in Europe, were dismissed as rubbish by the Nazis. The Fauvist painter Maurice Vlaminck took the opportunity to attack Picasso, no doubt hoping to curry favor with the German authorities. Vlaminck commented "Pablo Picasso is guilty of dragging French painting to a mortal impasse, a state of indescribable confusion. From 1900 to 1930 he has led painting to negation, impotence and death.... The only thing Picasso absolutely cannot do is a Picasso which is a Picasso."

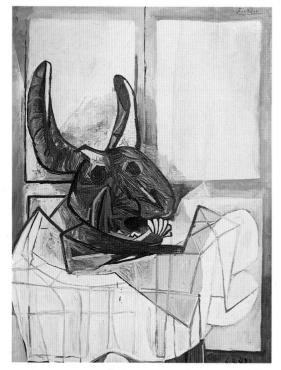

However, Picasso was not in danger and in time Marie-Thérèse and Maya joined him in Paris.

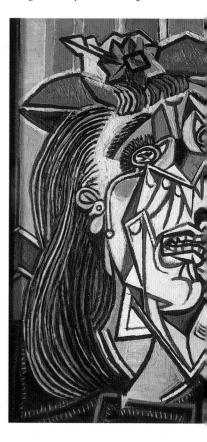

BULL'S HEAD ON A TABLE, 1942

Picasso painted this picture in the darkest hours of World. War II. Picasso's Jewish friends, such as Max Jacob, were rounded up by the Nazis. They were not to survive. The bull's head appears to be presented on a clean, white tablecloth as if served as a meal. The black and white rendering of the head and horns is splattered with red paint and the tablecloth is smeared with red. It is impossible to look at this violent still life without thinking of the animal brutality of war.

THE ARTIST'S VISION FAMOUS IMAGES

he devastation in Spain was a cause of anger and torment for Picasso. He feared for his family in Málaga, which had fallen to the fascists. On January 13, 1938, just days before Franco's army marched into Barcelona, Picasso's mother died. Hitler's forces were poised to strike at Germany's neighbors and Picasso feared for the safety of his

own family in France. In July 1938 Picasso sent Marie-Thérèse and daughter Maya away from Paris to the coast. On July 19 Picasso

And I have written several to you, which you must by now have received. I love you more every day. You mean everything to me. And I will sacrifice everything for you, and for our love, which shall last forever... My own tears would mean nothing to me if I could stop you from shedding even one. I love you. Kiss Maria, our daughter."

MAN WITH A LAMB, 1943

Picasso made almost one hundred preparatory drawings for this sculpture, starting in 1942 and continuing throughout the year and into 1943. The figure holding a lamb is a return to both classical and Christian imagery, referring to human values and the Lamb of God. The figure, which stands over two meters (six feet) high, was finally modeled in clay and then cast in 1944—a difficult process given the shortage of bronze in occupied Paris.

wrote, "My love, I have just received your letter.

THE AMERICAN Patron

In 1905 a young, wealthy American art collector named Leo Stein bought two of Picasso's paintings. Stein described Picasso as "a young Spaniard... whom I consider a genius of very considerable magnitude and one of the most notable draughtsmen living." Leo was living in

Paris with his sister. Gertrude, and the couple later visited Picasso in his studio. Picasso proposed painting a portrait of Gertrude for which Picasso insisted Gertrude pose over ninety times during the course of the painting. Leo and Gertrude became lifelong friends, and their patronage was extremely important in helping to establish Picasso's reputation. Before her death in 1947, Gertrude wrote of Picasso, "He alone among painters did not set himself the problem of expressing truths which all the world can see, but the truth which only he can see." The detail above (of Gertrude Stein) is from Renato Guttuso's painting, Totenmahl, a tribute to Picasso.

THE ARTIST'S INFLUENCE THE AUDIENCE FOR THE PICTURES

icasso was fortunate to find people who were ready to support him from a relatively early time in his life. When he was first in Paris, an art dealer, Ambroise Vollard, expressed an interest in Picasso's work and exhibited his paintings in his gallery. This show, in 1901, was Picasso's first real exhibition. Vollard and Picasso remained firm friends. with Vollard representing Picasso's work during his early career. It was the age when art dealers were making an increasing impact and helping to shape the world of art. Another young dealer, Daniel Kahnweiler, had recently started his business with a sum of money from his wealthy father. Kahnweiler heard about Picasso's Les Demoiselles d'Avignon and tried to buy it, but Picasso would only sell preliminary studies. Competition from dealers soon brought Picasso success. Apart from some difficult times when he was first living in Paris, Picasso was quickly able to support himself by the sale of his work. For an artist to support himself, particularly as a young man, is unusual. Artists have struggled to make ends meet throughout the history of art, often relying on private income to subsidize their art. Picasso's extraordinary genius was recognized instantly, providing him and his extended family an income that grew over the years into a considerable financial fortune.

ne d'Acrobate du ballet "PARADE" Aquarelle de Picasso.

Color print of a watercolor by Picasso, 1917

A letter of the time from Satie hints at some of the problems caused by Picasso's involvement with the ballet designs. "Parade is turning into something better, behind Cocteau's back. Picasso's ideas I find even better than those of our Jean: what a malheur! I am for Picasso, and Jean doesn't know it. What to do? Picasso tells me to work with Jean's text while he, Picasso, is using another, his own."The performance was a disaster in popular terms but has become a landmark in the history of ballet, one of the first truly modern pieces. *Right, Jean Cocteau drawing Maria Calvi*.

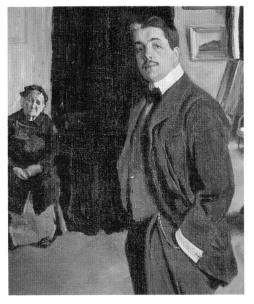

LA PARADE

Picasso's friendship with the composer Erik Satie led to an invitation to work on designs for a modern ballet, La Parade, which opened in Paris in 1917. Sergei Diaghilev, who had founded one of the greatest international ballet companies, the Ballets Russes, had commissioned Satie to compose the music for the ballet. The young writer and playwright Jean Cocteau was writing the scenario (story). Cocteau was aware of Picasso's circus paintings and was planning a ballet based on circus figures. Picasso's influence created a new approach. He designed Cubist costumes constructed from cardboard that made the dancers look like his Cubist paintings. Other costumes were based on his favorite theme, the harlequin. Above, portrait of Diaghilev by Leon Bakst, 1906.

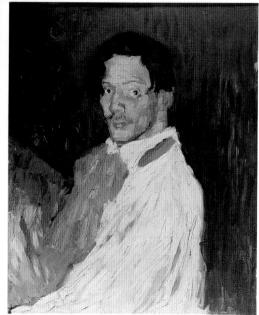

YO PICASSO, 1901

In 1967 an early blue period picture sold for \$532 thousand, the highest price ever paid for a work of a living artist. This 1901 self-portrait called Yo Picasso (I Picasso) came up for auction in 1981, just eight years after Picasso's death. It fetched a record price of over \$5.5 million. Picasso could accurately be described as a "legend in his own lifetime." His early critical success established his reputation. This was to grow steadily as demand from collectors and dealers further enhanced his standing. It is worth recalling, however, that Picasso had always been an obsessive painter, even from early childhood. He painted because he had to. Success was a by-product of that obsession.

THE ARTIST'S INFLUENCE WHAT THE CRITICS SAY

he first review of Picasso's work appeared in the Paris press in 1900, when his paintings were exhibited in Vollard's gallery. The critic Felicien Fagus wrote in the magazine, La revue blanche: "Picasso is a painter, absolutely and beautifully ... one can easily see many an influence apart from his own great ancestry; Delacroix, Manet, Monet, Van Gogh, Pissaro, Toulouse Lautrec, Degas... each one a passing phase... his passionate surge forward has not vet left him the leisure to forge for himself a personal style." This was certainly praise for a nineteen-year-old beginning to make his way in the world. Picasso did forge a personal style, but it was one that was always open to ideas and influences. His creative genius made his work too elusive, too varied to label as one style. The furor surrounding his 1907 painting, Les Demoiselles d'Avignon, brought criticism from not only the professional critics but even from his closest friends. Nevertheless Picasso had absolute faith in what he was doing. Today the critics recognize that the painting was revolutionary and has affected the course of twentieth-

century art.

HOMAGE TO PICASSO

Picasso's legacy of work is vast. Picasso Museums now exist both in his native Spain (in Barcelona) and in his adopted France (in Paris). The Picasso Museum in Paris now houses the famous *Maya with Sailor Doll* along with other works by Picasso.

State of the state

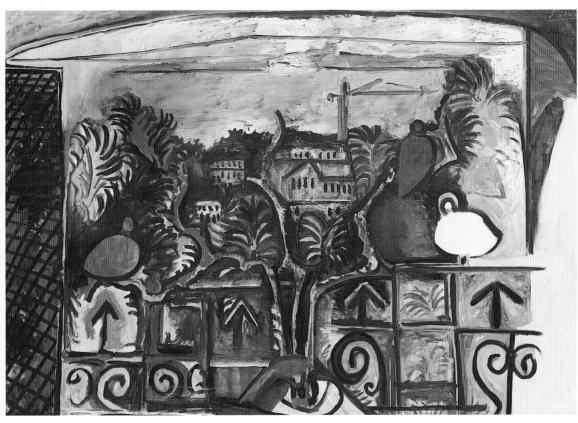

LANDSCAPE NEAR CANNES AT TWILIGHT, 1960

The art historians and critics have been dismissive of Picasso's later work. Many accounts and reviews of his art disregard most of his work from the late 1940s onward despite the fact that he continued painting until his death in 1973. Picasso was, of course, overtaken by the many new movements in art to which critics turned their attention. It is easy to forget that Picasso's life spanned virtually a century and that some of the greatest changes in the history of art occurred in this period. When he started painting the Impressionists were the dominant force; when he died Pop Art was already a thing of the past. When his last pictures were exhibited after his death. the critics called them "incoherent scribblings" and said they were the result of "senility." Who can tell what

DOVE OF PEACE

After World War II Picasso's political sympathies were with the communists, and he joined the French Communist Party. He went to the World Peace Congress in Poland in 1948 where he was met with the charge from the Soviets that "His works are a sickly apology for capitalist aesthetics that provoke the indignation of the simple people... his every canvas deforms man, his body and face." Nevertheless he was happy for his picture of a pigeon to be used on a poster for the "World Congress for the Partisans of Peace," sponsored by the French Communist Party in 1949. It was not exactly a dove, but it would do as the "dove of peace." While the congress was in session, Picasso's daughter was born and christened Paloma, Spanish for dove.

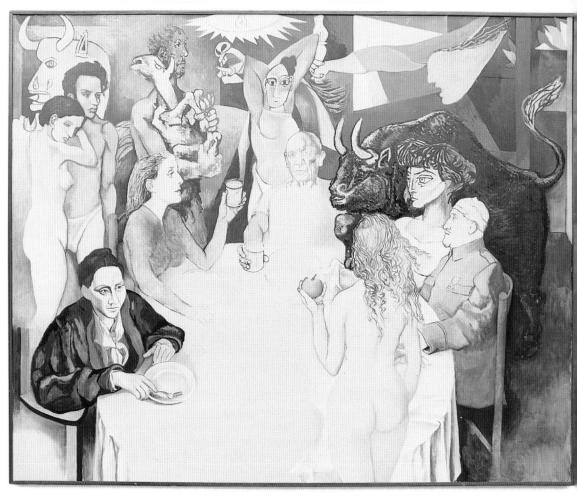

TOTENMAHL

Renato Guttuso

After Picasso's death in 1973, the Italian artist Renato Guttuso painted a tribute to him in the manner of a final meal or Last Supper with characters from paintings across all periods of Picasso's paintings and sculptures appearing around the table.

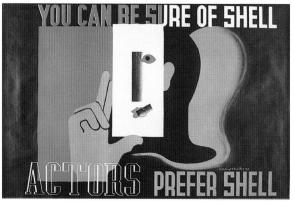

ADVERTISING STYLE

One of the most memorable aspects of Picasso's work is the rearrangement of facial features to make them appear on one flat plane rather than as we come to expect them to look in life, or in conventional art that tries to mirror life. Picasso's challenge to how we see things caused him to depart from traditional representation and was part of his development of what we call today analytical cubism. Picasso is famous for pointing out that the untutored eye of a young child will draw things how he or she sees them—often like Picasso's flat faced

portrait—and that the freshness of observation so sought after by artists is destroyed by teaching. This 1930s poster for Shell recalls the compositional style of Picasso's Cubist work.

THE ARTIST'S INFLUENCE A LASTING IMPRESSION

icasso is arguably the most important artist of the twentieth century. He produced a huge number of paintings, drawings, prints, and sculptures, and most museums of modern art throughout the world have examples of his work. Today art historians place his name alongside those of Giotto and Michelangelo because, like them, Picasso's work represents a radical change in the course of Western art. He is said to have freed painters from "the tyranny of representational art," meaning that he made it possible for those who followed to develop nonrepresentational-abstract-art. It is for abstract art that the twentieth century will be remembered, and it is Picasso who helped make abstract art possible. The huge range of Picasso's work encompasses many different styles. He evolved cubism with fellow artist Braque; he invented collage; he helped evolve surrealism and, of course, abstract art. In later life Picasso considered himself part of the long-standing tradition of painters such as Velazquez and Manet rather than the new generation whose careers could never bear comparison with Picasso, the master.

Picasso taken for ride by thief in pony-tail

CONTINUING FAME

Picasso's works are still actively traded in the art dealing rooms today. When a painting from an important period in his life comes up for sale, it will command many millions of dollars. However thousands of his drawings, prints, and lesser paintings frequently change hands through the dealers. The recent theft of one of Picasso's works made newspaper

headlines. The incident underlines not only how valuable even the smaller Picasso pictures are but the strange things some people will do to own a picture by the master of the twentieth century.

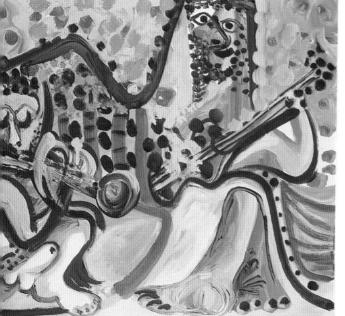

AFTER GUERNICA

Musicians, 1972

A major exhibition of Picasso's work was held at the National Gallery in Berlin in 1992. This exhibition concentrated on his artistic output after the world famous *Guernica*, painted in 1937. Although it is considered that Picasso's influence was most profound during the earlier part of his career and that art historians see *Guernica* as his last great work, we should not overlook the paintings that followed. This picture was painted when Picasso was ninety-one years old.

and the second second

GLOSSARY

Collage - The name given to pictures that are made wholly or partly from pieces of cloth, paper, or other materials glued onto the canvas. The technique was first introduced by Picasso and Braque in the early days of cubism. Futurism - An art movement founded in 1909, composed mainly of Italian artists, which rejected everything from the past in favor of modernism. Futurists loved machinery and concerned themselves with capturing movement, the essence of all things modern. Mural - The word "mural" is used to describe any kind of wall painting. It is not the same as fresco, which refers to a particular method of painting on plaster.

Objets Trouves – This means literally "found objects" and is mostly associated with the

surrealist movement. It refers to everyday practical objects that might be found anywhere and are given a new meaning by the artist, like Picasso's

bicycle saddle (seat) and handlebars becoming a bull's head.

Representation - Until the advent of abstract art in the twentieth century all Western art "represented" people, objects, and scenes in a recognizable way. After the fourteenth-century artist Giotto, and the advent of the Renaissance, visual

rules about how things were represented were generally obeyed. **Surrealism** – The word "surrealism," first

coined by Picasso's friend Apollinaire in 1917, was used to describe art that produced strange juxtapositions to create dreamlike, irrational imagery.

ACKNOWLEDGMENTS

ticktock Publishing, LTD UK would like to thank: Graham Rich, Tracey Pennington, and Peter Done for their assistance.

Acknowledgments: Picture Credits t=top, b=bottom, c=center, l=left, r=right, OFC=outside front cover, IBC=inside back cover, OBC=outside back cover.

All works by Pablo Picasso © Succession Picasso/DACS 1997.

AKG/Sotheby's. Photo © AKG London; 28tl. Photograph of Picasso, 1933, Man Ray © Man Ray Trust/ADAGP, Paris and DACS, London 1997 (Photo © AKG London); 24tl. Photo © AKG London; 2bl, 3bl, 3c, 4bl, OBC & 6/7cb, 8tl, 8cb, 10cb, 12tl, 23tl, 24tl, 27tl. Photo © AKG London/AP; 21tr, 20/21c. Photo © AKG London/Paul Almasy; 27br. Photo © AKG London/David Douglas Duncan; OBC & 12c, 12br. John Daniels/Ardea London; 29b. Mary Evans Picture Library; 2tl, 3tr, 22bl. FORBES Magazine Collection, New York/Bridgeman Art Library, London; 3br. Galerie Jan Krugier, Geneva. Photo © AKG London; 29t. Design Council; 30bl. First published by The Independent (Jason Bennetto, Crime Correspondent); 31tr. Pablo Picasso, Les Demoiselles d'Avignon. Paris (June-July 1907) oil on canvas, 8' x 7'8" (243.9 x 233.7cm). The Museum of Modern Art, New York. Acquired through the Lillie P. Bliss Bequest. Photograph © 1997 The Museum of Modern Art, New York; 16/17c & detail 16cb. Museum of Art, Philadelphia. Photo © AKG London; 17tr, 25br. Museum of Modern Art, New York. Photo © AKG London/Erich Lessing; 6bl. Museo Nacional Reina Sofia, Madrid. Photo © AKG London; 22/23c & 23bl. Musee Picasso, Barcelona. Photo © AKG London; 5cr. Musee Picasso, Paris. Photo © AKG London; IFC/1 & 11br, 5tl, 9bl, 13tl, 21br. Family of Saltimbanques, Chester Dale Collection © 1997 Board of Trustees, National Gallery of Art, Washington, 1905, canvas, 2.128 x 2.296 (83% x 90%); framed: 2.404 x 2.563 (94% x 100%); 14tl & detail 14bl, 14br & 15tl.15tl. National Gallery of Art, Washington. Photo © AKG London; 15tr. Les Acrobats, 1930, Fernand Leger © ADAGP, Paris and DACS, London 1997 (Private Collection. Photo © AKG London); 7tr & 7br, OFCl & 11tr, 18tl, 31bl. Pinacoteca di Brera, Milan. Photo © AKG London; 24bl. Pushkin Museum, Moscow. Photo © AKG London/Erich Lessing; 15cb, 18/19b. Sammlung Heinz Berggruen, Geneva. Photo © AKG London; OFCr & 9tr. Totenmahl, Renato Guttuso © DACS 1997 (Sammlung Ludwig, Aachen. Photo © AKG London); 26tl & 30t. Solomon R. Guggenheim Museum, New York. Photo © AKG London; 5bl. Staatl. Russisches Museum, St. Petersburg. Photo © AKG London; 27tr. Music, 1910, Henri Matisse © Succession H Matisse/DACS 1997 (State Hermitage, St. Petersburg. Photo © AKG London); 6tr. State Hermitage, St. Petersburg, Photo © AKG London/Erich Lessing; OBC & 19tr. © Photo RMN-Arnaudet (Musee Picasso, Paris); 28bl. © Photo RMN (Musee Picasso, Paris); 10tr. Tate Gallery, London. Photo © AKG London/Erich Lessing; 24/25c. Dr. Werner Muensterberger Collection, London/Bridgeman Art Library, London; OBC & 16tl.

Every effort has been made to trace the copyright holders and we apologize in advance for any unintentional omissions. We would be pleased to insert the appropriate acknowledgment in any subsequent edition of this publication.